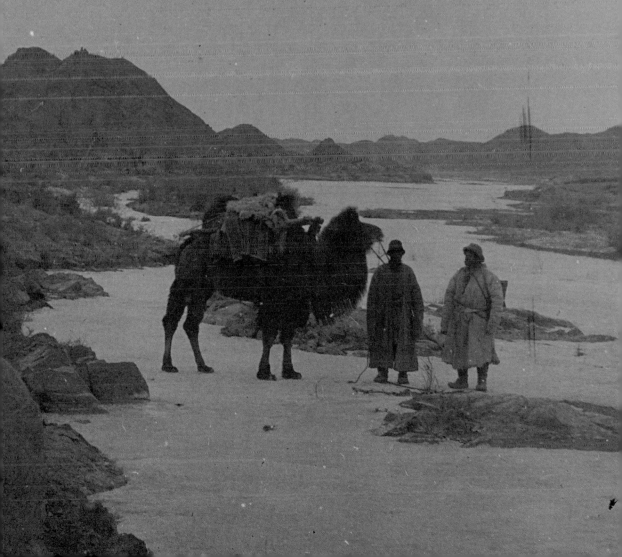

THE SILK

Trade, Travel, War and Faith

Susan Whitfield

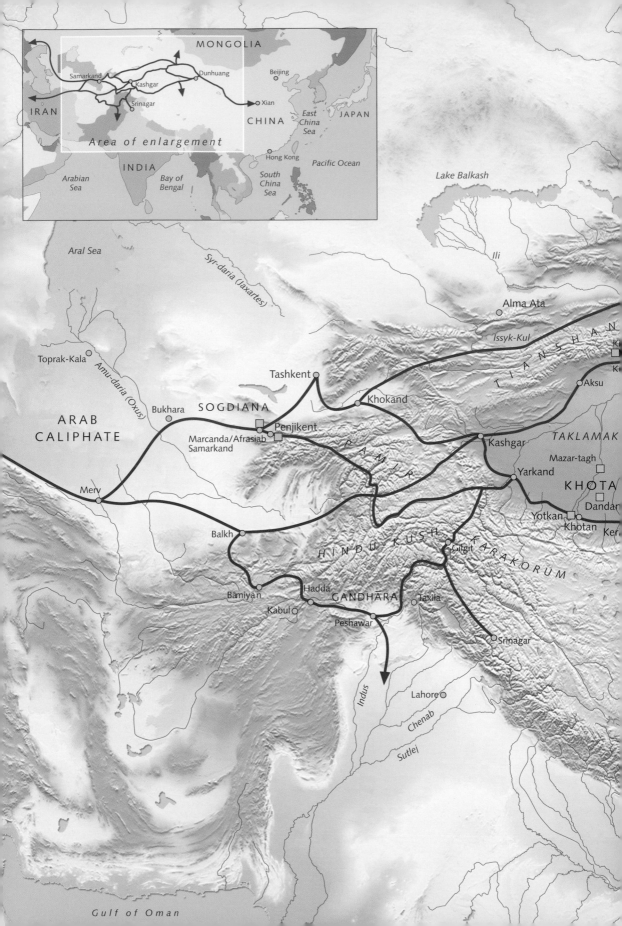

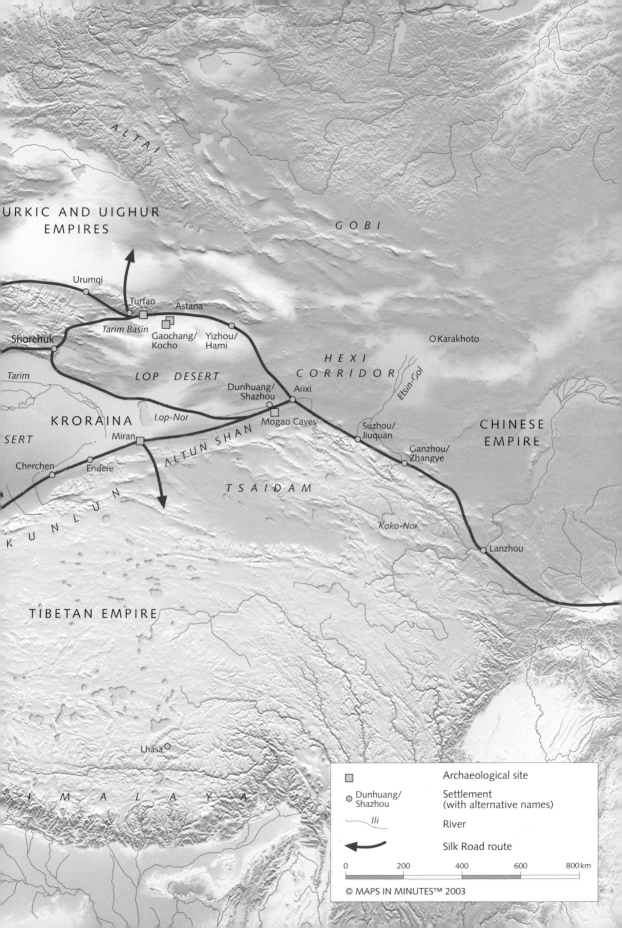

URKIC AND UIGHUR
EMPIRES

ALTAI

GOBI

Urumqi

Turfan

Astana

Shorchuk

Tarim Basin

Gaochang/
Kocho

Yizhou/
Hami

Karakhoto

Tarim

LOP DESERT

HEXI
CORRIDOR

Etsin-Gol

KRORAINA

Lop-Nor

Dunhuang/
Shazhou

Anxi

SERT

Miran

Mogao Caves

Suzhou/
Jiuquan

CHINESE
EMPIRE

Cherchen

Endere

ALTUN SHAN

Ganzhou/
Zhangye

K U N L U N

TSAIDAM

Koko-Nor

TIBETAN EMPIRE

Lanzhou

Lhasa

H I M A L A Y A

Archaeological site

Dunhuang/
Shazhou

Settlement
(with alternative names)

Ili

River

Silk Road route

0 200 400 600 800 km

© MAPS IN MINUTES™ 2003

INTRODUCTION

The Silk Road is a simple name for a complex network of ancient trade routes. From earliest times these led from the shores of the Mediterranean Sea on the borders of Europe, through Samarkand at its centre and on to central China. Silks, spices and perfumes, precious stones such as jade and lapis lazuli, and all manner of commodities were traded along this route. But the Silk Road also transported cultural influences – knowledge and ideas, customs and religions, art and science – and it is this extraordinary weaving of civilisations which has made the Silk Road a complex entity, exciting both historical and romantic interest.

Being beguiled by the Silk Road is nothing new. For over two millennia it has attracted those wishing to make money, converts, diplomatic deals and conquests – or those simply looking for a quiet place of retreat. For the scholar and archaeologist Aurel Stein (1862–1943) it was a region largely unexplored, with scholarly secrets yet to be uncovered and where, he hoped, he could make his reputation. He was not to be disappointed.

As a schoolboy, Stein had read the account of how Alexander the Great had led his army from Greece almost 3,000 miles to reach the heart of Central Asia, conquering all on his way. From then on, Stein had been intrigued by this region. Alexander had hoped to reach China, but only travelled halfway, to the Pamir Mountains, before he moved south into India. Had he crossed the Pamirs, he would have encountered over a thousand miles of the Taklamakan and Gobi deserts before the landscape softened gradually into the fertile plains of central China. It was this eastern half of the Silk Road that was to occupy thirty years of Stein's life.

During four major expeditions on the eastern Silk Road between 1900 and 1930, Stein journeyed across the area between the Pamirs and China several times on foot and horseback, excavating ancient ruins long covered by the desert sands and discovering tens of thousands of manuscripts, paintings and artefacts dating from the second century BC to the fifteenth century AD. It is Stein's explorations in the ancient kingdoms of this region, his finds and their stories, that form the focus of The British Library's Silk Road exhibition in 2004.

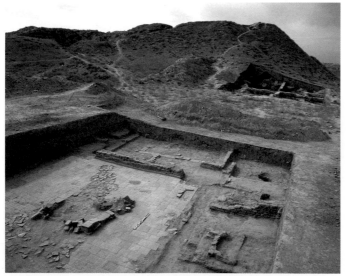

The remains of the Afrasiab citadel near Samarkand where Alexander the Great killed Clitus. The classical writer Arrian described this event: 'Alexander leapt up in passion to kill Clitus. Clitus was hurried away outside through the doors over the wall and ditch of the citadel ... by Ptolemy son of Lagus, but could not control himself, and turned back; he met with Alexander ... and there and then was struck with the pike and died.'
Photograph by Yury Karev; Courtesy of MAFOUZ

Sogdiana and Samarkand: Trade and Diplomacy

One of Alexander the Great's final conquests, before he turned south to India, was the city of Marcanda – the ancient city of Samarkand in present-day Uzbekistan. The remains of the Afrasiab citadel where Alexander stabbed Clitus to death in 328 BC can still be seen near the modern Islamic city. Five hundred years after Alexander, the ancient city was again thriving and was home to many of the most successful merchants of the Silk Road. This region beyond the Oxus River was called Sogdiana, and Sogdian merchant communities stretched east from Samarkand into China acting as agents for their compatriots back home, organising the trade of all manner of goods.

In about 314 AD, a bundle of letters from members of a Sogdian community in the Silk Road town of Dunhuang was dropped and buried by the desert sands, only to be discovered over 1,500 years later by Stein. It contained five letters on paper, folded carefully with the address and recipient inscribed on the outside. One was from Miwnay, a Sogdian merchant's wife, who had been abandoned. She urges her husband to return as she is destitute, having had to pay off his debts and been forced to work as a servant for a local Chinese household: 'I would rather be a dog's or a pig's wife than yours!' (Fig. 1, p. 19).

It was not only goods that people carried along the Silk Road: they also brought their knowledge and beliefs. The Sogdians were originally Zoroastrians – fire worshippers – with a religion dating back to Zoroaster (or Zarathustra) who lived in Persia in the sixth century BC. Eternal fire was the symbol of their god Ahura Mazda, Lord Wisdom, and fire altars were situated throughout Persia and into Sogdiana. However, in the third century AD, a prophet from Babylon called Mani argued that he was the culminating prophet following Zoroaster, Buddha and Jesus and that his faith was the true one. The priests of Mani's religion, the Elects, were to abstain from marriage, alcohol, meat, and the killing of any animal or plant. Mani himself travelled to India but it was Mar Ammo, the Disciple of the East, who brought the new religion to Sogdiana. Mani was persecuted to death in Sasanian Persia, but his religion took hold on the eastern Silk Road. The neighbouring Uighurs, a powerful confederation of Turkic tribes, were converted in the mid-eighth century, and vestiges of Manichaeism are seen in the fragments of illustrated scriptures from the Uighur Silk Road kingdom of Kocho near present-day Turfan. Painted using blue from lapis lazuli, vermilion red and gold paint, they are vivid depictions of this once thriving religious community (Fig. 2, p. 20).

The Sogdians and Chinese at either end of the eastern Silk Road exchanged numerous trade and diplomatic missions, and were inevitably influenced by each other's culture, as shown in the sixth-century funerary couch of a Sogdian merchant resident in China (Fig. 3, pp. 20-21). The carved marble panels, coloured with red and gilt, show Zoroastrian funerary rites as well as the Sogdian merchant and his Chinese wife watching Sogdian- and Chinese-style dancing.

Khotan: A Meeting of Cultures

It was this interchange of cultures that attracted Stein to the eastern Silk Road and, in particular, to the ancient kingdom of Khotan east across the Pamir Mountains from Samarkand on the road to China. Stein had heard of manuscripts discovered in ancient desert cities by treasure-seekers and sold to the British and Russian Consuls in Kashgar. Eager to explore these ruins for himself, he made Khotan the focus of his first expedition in 1900.

> 'For systematic excavations, which alone could supply this evidence, the region of Khotan appeared from the first a field of particular promise. In scattered notices of Chinese records there was much to suggest that this little kingdom, situated on the important route that led from China to the Oxus Valley and hence to India as well as to the West, had played a prominent part in developing the impulses received from India and transmitting them eastwards. The close connection with ancient Indian art seemed particularly marked in whatever of small antiques, such as pottery fragments, coins and seals, native agency [trading agents] had supplied from Khotan. And fortunately for our researches, archaeology could here rely on the help of a very effective ally – the moving sand of the desert which preserves whatever it buries. Ever since human activity first created the oases of Khotan territory, their outskirts must have witnessed a continuous struggle with that most formidable of deserts, the Taklamakan; while local traditions, attested from an early date, told of settlements that had been abandoned before its advances.'
>
> (Stein, from his book *Sand-Buried Ruins*, xv)

Khotan was not to disappoint. Throughout the first millennium it had been open to influences from the Persian west, the Indian south and China to the east.

> 'The ruined sites explored by me have more than justified the hopes which led me to Khotan and into its desert. Scattered over an area which in a straight line extends for more than three hundred miles from west to east, and dating back to different periods, these ruins reveal to us a uniform and well-defined civilisation. It is easy to recognise now that this bygone culture rested mainly on Indian foundations. But there has also come to light unmistakable evidence of other powerful influences, both from the West and from China, which helped to shape its growth and to invest it with an individual character and fascination of its own.'
>
> (Stein, *Sand-Buried Ruins*, xv–xvi)

Dandan-Uiliq was one such ruin half-buried by the desert sands but once a thriving town in the kingdom of Khotan. A wooden panel discovered here by Stein depicts Persian-style horse and camel riders, and the still perplexing iconography of a black bird flying into a bowl (Fig. 4, p. 23). The dappled horse, ancestor of the Appaloosa breed of horses, hailed from the Tianshan – or Heavenly Mountains – which rise north-east of Samarkand. The influence of the Indian south was similarly pervasive: many of the ruins were Buddhist temples replete with vividly painted murals. A Khotanese legend tells how the founding king of the Khotan kingdom prayed for a son at the temple of Vaiśravaṇa, one of the four Guardian Gods of Buddhism. A baby boy emerged from the head of the statue and was fed on milk from a breast which arose from the ground. From then on, Vaiśravaṇa was seen as the Guardian of Khotan and he appears in numerous Silk Road paintings (Fig. 5, p. 24).

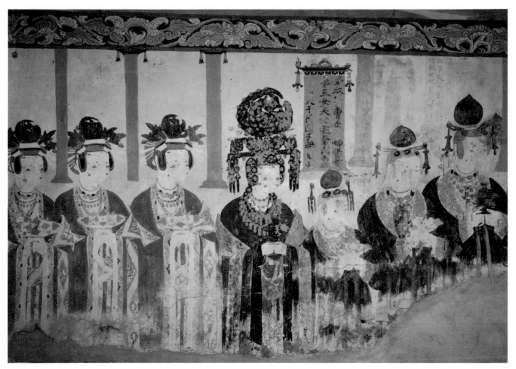

A tenth-century mural from the wall of the Buddhist cave temple 61 at Dunhuang, on the Silk Road, depicting a Khotanese princess (in the centre) with an elaborate headdress and necklace of jade. She is shown with other wives and relations of the king of Dunhuang, who is painted on the opposite wall; they were donors to this cave temple. Courtesy of the Dunhuang Academy

Another Khotanese legend tells of a marriage alliance agreed between China and Khotan. The Khotanese king wrote to the Chinese princess who was to be his bride warning her that she would no longer be able to wear fine silk clothes unless she brought with her the secret of silk. The Chinese border guards were instructed to search travellers to prevent anyone smuggling out knowledge of how this valuable textile was produced. The princess, however, cleverly hid silkworms and mulberry leaves in her elaborate headdress and evaded detection. Whatever the real story, Khotan had a thriving silk industry by the middle of the first millennium. It was also the major supplier of jade to China and of rugs (Fig. 6, p. 25), carpets and other textiles to the Silk Road.

The ruined sites of Khotan also yielded scores of manuscripts, written on wood and paper, in an Indian script but an unknown language. This was soon deciphered and recognized to be an Iranian language which is now called Khotanese. The documents give hitherto unknown information on the kings of Khotan and their administration in the seventh and eighth centuries, including the rule of the Tibetan conquerors from the mid-eighth century.

An extremely rare find was that of the earliest known manuscript (late eighth century) written in Judaeo-Persian – the type of Persian used by Jews and generally written in Hebrew characters. The manuscript is a business letter concerning the trading of sheep and the sale of garments (Fig. 7, p. 26). However, the language on some of the documents previously 'discovered' by one of the many treasure-seekers lured to the Silk Road by the promise of potential wealth to be found there, proved more difficult to decipher. Stein tracked down the supplier, questioned him over several days and eventually got him to admit that his 'finds' were, in fact, all creations in a made-up script – Silk Road forgeries (Fig. 8, p. 26).

Kroraina: Everyday Oasis Life

In the third and fourth centuries AD, Khotan's eastern neighbour was the kingdom of Kroraina, centred around what is now some of the most barren terrain on earth – the Lop desert. The people of this kingdom (known as Loulan in Chinese sources), had a sophisticated administration which left behind many of its archives when the tax-collectors and other officials abandoned the desert towns. Written in Kharoṣṭhī, a script developed and used exclusively in Central Asia over this period, the language was Gāndhārī, a dialect of Indian Sanskrit used in the Gandhāran region around present-day Taxila in Pakistan. Gandhāran art is renowned for its Greek influence, and Stein was a frequent visitor to Lahore Museum, then in British India, where he was able to study their fine Gandhāran art collection. (The museum's curator at the time was Rudyard Kipling's father, Lockwood, and Kipling describes the museum and its statues in the first chapter of his famous novel, *Kim*.)

The desert kingdom of Kroraina was 1,000 miles east of Gandhāra en route to China, and the Gandhāran influence is seen not only in the use of the language, but also in the seals used to keep secret the contents of the ingeniously constructed wooden envelopes until they reached their destinations. Found alongside the seals depicting Pallas Athene and other Greek gods and goddesses are those with Chinese characters, showing influences from the east as well as the west (Fig. 9, p. 28).

The documents provide many clues as to the everyday life of the residents of this desert kingdom. For example, Fig. 10 (p. 28) shows a letter from the king to the local governor concerning a dispute over bride-price. One of the terms for bride-price was *lote* – the same term was used for the 'ransom' a slave could pay for freedom – and it might consist of an exchange of a daughter from one family for the sister of the groom or, in the case of an older woman, an exchange for a younger one, perhaps with a camel and a horse added to the deal. Despite this trading, women were nevertheless accorded many legal rights in Krorainan society, including property rights and power over their inheritance. Without these documents we would know little, if anything, of women in this community.

Stein was unusual for his time in showing an interest in all the objects he excavated, however small or fragmentary: it was more common then for archaeologists to root through a site seeking only the treasures. Heinrich Schliemann in his excavation of the ancient city of Troy in the early 1870s had challenged this and the more

A typical Gandhāran-style Buddha, with its
fine modelling, showing Hellenistic influence.
This photograph was taken by Fred Andrews, one of
Aurel Stein's oldest friends, in the Lahore Museum
when Lockwood Kipling was curator.
The British Library, Photo 392/48(40)

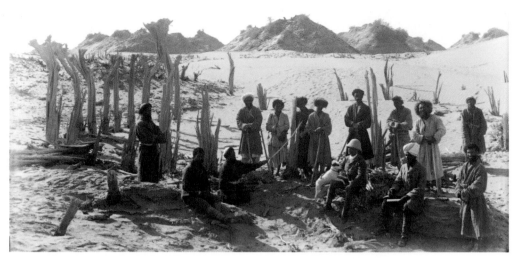

Stein, his dog Dash, Indian surveyors and the diggers at the ancient remains of a water tank at Niya.
The British Library, Photo 392/27(97)

systematic method of excavating carefully layer by layer, using the layers for dating and keeping a careful record of all finds, was to become standard in the twentieth century following publication in 1908 of Flinders Petrie's seminal work, *The Methods and Aims of Archaeology.* Stein was drawn to the ancient remains of Khotan and Kroraina not because he hoped to find treasures like those being excavated in ancient Egyptian tombs by his contemporaries, but because of their mundanity:

> 'The dwelling places, shrines, etc., of those ancient settlements had, no doubt,
> before the last desert sand finally buried them, been cleared by their inhabitants
> and others of everything that possessed intrinsic value. But much of what they
> left behind, though it could never tempt the treasure-seekers of succeeding ages,
> has acquired for us exceptional value. The remains of ancient furniture such as
> the wooden chair [now thought to be a table or an altar base, Fig. 12, p. 29];
> … the shreds of silks and other woven fabrics; the tatters of antique rugs [Fig. 6,
> p. 25]; the fragments of glass, metal and potteryware; the broken pieces of
> domestic and agricultural implements, and the manifold other relics, however
> humble, which had safely rested in the sand-buried dwellings and their deposits
> of rubbish – these all help to bring vividly before our eyes details of ancient
> civilisation that without the preserving force of the desert would have been lost
> for ever.'

<div align="right">(Stein, Sand-Buried Ruins, xviii)</div>

When Stein arrived at the desert site of Niya in ancient Kroraina, all that was visible were ancient wooden poles sticking out of the sands and some ruined Buddhist shrines, yet this was once one of the largest oases on the southern Silk Road and was to prove an immensely rich archaeological resource. Stein identified over forty structures during his four visits and a Sino-Japanese team excavated another thirty in the 1990s. The searing desert wind had long ago destroyed most of the clay buildings, but the poplar-wood skeletons and carved beams which once supported the roofs of the many half-timbered houses had survived in the dry desert atmosphere (Fig. 11, p. 29). Where buried by the sand, the woven reed walls which filled the gaps of the wood skeleton had also been preserved. The walls were tied to the wooden posts by raffia rope.

9

From the scanty remains, Stein was able to plan out the houses and his description of one room gives some idea of the scale and importance of these buildings as well as offering clues as to their furnishings:

> 'It measured 20 ft square, and showed a raised platform of plaster 3 ft 8 in broad and 13 in high along its north and west sides. By a door 2 ft 9 in broad and 6 ft 4 in high … it communicated with the hall. Another door, slightly wider, but only 5 ft 4 in high, formed the entrance from the passage westwards. The single wooden leaf which once closed it was found in good preservation, and still on its hinges … A little to the east of the centre of the room two round posts were found, 10 ft high, which had probably supported a raised portion of the roof serving as a skylight; for just between the two posts the floor showed a small oblong area sunk 6 in below the general surface, which had undoubtedly been used as a fireplace. … Within this … lay several torn fragments of the same fine coloured rug [Fig. 6, p. 25], which I shall have to describe presently in connexion with the central hall …'
>
> (Stein, *Ancient Khotan*, 332)

The table or altar frame (Fig. 12, p. 29) was found in pieces just outside this room with the carved faces to the ground, hence their preservation. Stein photographed them separately before he realised that they fitted together: only one panel was missing. He saw in their decorative motifs the influence of Gandhāran art. However, while influence of Gandhāran art on the oases of the southern Silk Road is undeniable, identification and interpretation of motifs is not always unproblematic as they travel across cultures and faiths and, in the process, attain new iconographical meanings.

Miran: Warring Empires

The First Tibetan Empire was formed in the early seventh century and, until the Silk Road excavations of Stein, the primary source for its history was from the accounts of the neighbouring – and often hostile – empire of China. However, among the documents discovered by Stein on the Silk Road was a copy of the Tibetan annals, giving entries for the years 629 to 764 (Fig. 13, p. 31). This is one of the earliest documents in Tibetan script, which was invented on the basis of Indian scripts at the start of the First Empire in the early seventh century.

By the seventh and eighth centuries, the Chinese empire to the east and the Tibetan empire to the south were vying for control of the Silk Road kingdoms and the profits from their local industries and their thriving trade. In 755 a Chinese general rebelled and central China was plunged into civil war. Troops from the Silk Road were recalled to help defeat the rebels and Tibetan soldiers moved in, taking control of these eastern Silk Road kingdoms, including Khotan and the area once controlled by Kroraina. The Tibetans built major forts and a series of connecting watch-stations. One fort, north of Khotan, protected the kingdom from the northern Turks while that of Miran, east of Niya, protected the route south through the mountains to the heartland of Tibet. For nearly a century, Tibetan and locally raised troops, their families and support staff lived in these forts. The small rooms built against the walls were used for trash and as toilets, and a thousand years after the troops' departure Stein discovered thousands of artefacts in these ancient rubbish tips. His account reveals one of the unpleasant surprises of desert excavation:

'In the midst of inconceivable dirt, sweepings from the hearth, litter of straw, remnants of old clothing and implements, and leavings of a yet more unsavoury kind, there were to be picked up in plenty Tibetan documents on wood and paper ... From a single small apartment, measuring only some eleven by seven feet, and still retaining in part its smoke-begrimed wall-plaster, we recovered over a hundred such pieces. The amount of decayed animals and vegetable matter which had found a resting-place in these walled-in dustbins had often caused the remains of written materials to be encrusted so thickly that it required much attention and care to spot and extract them. An all-pervading smell of ammonia brought home the fact that each of these little rooms, after being used as quarters by dirt-hardened Tibetan soldiers, must also have served them intermittently for purposes far more offensive.'

(Stein, *Ruins of Desert Cathay*, 439–40)

Many of the wood slips were tallies for soldiers to take to their watch-station postings. The names of the soldiers were written on the backs and show that the commander and his deputy were usually Tibetans, whereas local Khotanese were employed as cooks (Fig. 14, p. 31). Also found among the ancient rubbish were scales of the lacquered leather armour worn by Silk Road soldiers (Fig. 15, p. 32).

Several of the gods in the large Buddhist pantheon were typically depicted in the guise of soldiers defending the Dharma or Buddhist Law. Vaiśravaṇa (Fig. 5, p. 24), the Guardian of Khotan, was often called upon for his help in defeating earthly enemies. In the seventh century, for example, when Arab soldiers took a Chinese Silk Road garrison, the Chinese emperor asked one of his Buddhist advisors to pray to Vaiśravaṇa for aid. By this time, although the Sogdians were converting to Islam, and Zoroastrian, Manichaean and Nestorian Christian communities continued to exist along the eastern Silk Road, Buddhism was the dominant religion from Khotan eastwards. The Tibetan emperors showed a preference for the tantric or esoteric school of Buddhism, unlike China's Buddhists who favoured other Mahāyāna schools. However, the documents from the Silk Road give little evidence of sectarianism at this early period and rather show a blurring of the beliefs and practices of the different schools.

By the eighth century, Tibet was only one of four powerful empires seeking influence on the eastern Silk Road. China to its east was an old enemy. The north, present-day Mongolia, was held by a succession of Turkic empires. And by this time, Arab forces had conquered the central Silk Road region of Sogdiana and were pushing towards the Pamirs. The Tibetans clashed frequently with all these, but were known as a powerful military force, the bravery of their infantry being singled out for praise by Chinese historians. At this point, however, all the armies had strong, well-equipped cavalry units, often with their horses also clad in armour (Fig. 16, p. 33).

The military were not the only ones with equine skills. The Silk Road sport of polo had become immensely popular among the aristocratic men and women of China (Fig. 17, p. 32), and the imperial palace boasted a polo field and stables of fine Silk Road ponies. The Chinese were therefore keen to regain control of the Silk Road and the trade in fine horses from the valleys east of Samarkand. However, it was almost a century before the Tibetans were driven out by Chinese and other forces as their own empire crumbled. In Dunhuang, to the east of Miran, the victorious Chinese-loyalist army of General Zhang is depicted in a contemporary mural (p. 12).

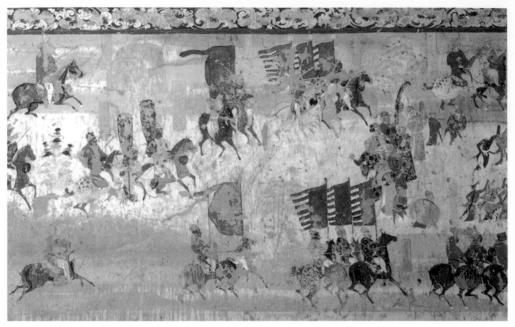

A wall-painting in cave 156 in Dunhuang shows the victory procession of the Chinese loyalist, General Zhang, after his defeat in 868 of the Tibetan forces ruling Dunhuang.
Courtesy of the Dunhuang Academy

Dunhuang: Official Life and Faith

While the landscape of the Silk Road changed dramatically along its length, the stars in the sky were the same for travellers on the shores of the Mediterranean and those in Dunhuang. The principal trade routes lie mainly between 30° and 40° latitude in the northern hemisphere and because the constellations in both regions were the same, the knowledge and myths associated with the heavenly bodies were largely portable from one culture to another. Babylonian ideas had probably been integrated into Chinese knowledge by the sixth century BC, and Greek ideas merged with those from India, both disseminating into China. Knowledge of the stars continued to spread along the Silk Road, brought especially by the Arabs towards the end of the first millennium AD.

Court astronomers of ancient China were as much concerned with the influence of the stars as with learning about them, but their astronomical knowledge was nevertheless accurate, as is shown in a unique manuscript star chart from Dunhuang (Fig. 18, p. 35). The 1,585 stars are accurately drawn in a projection very similar to that used today and grouped into constellations. This chart, which is the earliest surviving manuscript of its kind, was probably a reference work for military and travellers' needs. However, the start of the manuscript contains diagrams of clouds formed into certain shapes, with text below them explaining their predictive power, and this suggests that the charts may also have been used for divination.

By the sixth and seventh centuries in China, the stars were part of a complex group of beliefs which ranged from lucky and unlucky days, through *fengshui*, the power of talismans and the predicative power of heavenly signs, to the zodiacal animals. Privately produced almanacs of the time included all these elements and were enormously popular, despite the fact that the making of calendars was strictly reserved for the imperial astronomers (Fig. 19, p. 36).

By the tenth century, although Dunhuang was no longer under Tibetan rule and offered allegiance to China, it had become semi-autonomous. One of the roles of local officials therefore was to calculate the official calendar. Other duties included keeping accurate records of land holding, taking regular censuses, resolving legal disputes, meeting with foreign dignitaries (Fig. 20, p. 37) and ensuring the defence of the kingdom. The last was not always straightforward, as the Turkic Uighurs had been driven out of their empire in Mongolia and now formed a strong kingdom to the north of Dunhuang, and the Arabs and Tibetans were still pressing to the west and south. These unsettling times are reflected in a printed prayer sheet of 947 (below), which shows a Buddhist image and was commissioned by the ruler of Dunhuang, Cao Yuanzhong:

> 'to the end that the city god may enjoy peace and prosperity, that the whole prefecture may be tranquil, that the highways leading east and west may remain open; that evil-doers north and south may be reformed, that diseases may disappear, that the sound of the war-gong may no longer be heard, that pleasure may attend both eye and ear, and that all may be steeped in happiness and good fortune.'

The name of the carver of this woodblock, Lei Yanmei, is given at the end of the text. By this time woodblock printing was a mature art in China and along the Silk Road. It probably has its origins in the seals common in ancient China and the small woodblocks of Buddha figures used in early Buddhist ritual and art. From these developed the idea of larger woodblocks carved with a whole page of text and page-sized images. Buddhism was quick to exploit this new technology as it enabled the speedy production of multiple images of Buddha and his words, acts which brought the copier and donor merit. It is not surprising, therefore, that the earliest complete, dated, printed book in the world is a Buddhist sutra known as the Diamond Sutra. Dating to 868 it was commissioned by a man called Wang Jie on behalf of his parents and, with its fine frontispiece (Fig. 21, p. 38), it is clearly the product of a mature printing technology.

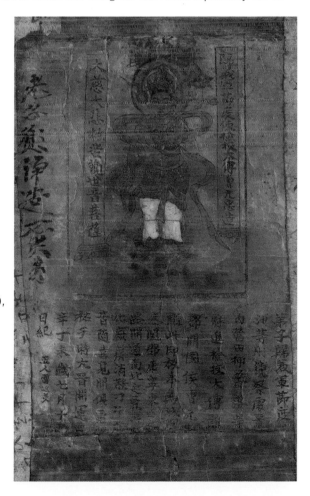

The image of the bodhisattva of compassion, Avalokiteśvara, on this prayer sheet from Dunhuang, has been hand-coloured after the outline was printed in black ink using a carved woodblock. The text is translated above. It dates to 947, several centuries before printing was developed in Europe.
The British Library, Or. 8210/P. 9

Astana: Death and the Afterlife

In 640 the Chinese took control of Gaochang, a kingdom to the north-east of Dunhuang on an important route north through the Heavenly Mountains to the Turkic Empires beyond. They used a large plain north of the walled city as a graveyard – now known as the Astana and Karakhoja cemetery – and, over the following two centuries before the Turkic Uighurs seized control, hundreds of Chinese officials and residents of Gaochang were buried here in underground brick-lined tombs, reached by sloping passageways.

The graves reflect traditional Chinese beliefs. The entrance was guarded by fierce monsters made from vividly painted clay (Fig. 22, p. 40) to prevent evil spirits entering. The body was wrapped in textiles and paper, the eyes and face covered with a mask and one or more coins placed in the mouth. Some of the coins were gold drachmas from Byzantium, brought here by Silk Road merchants and others were locally minted imitations (Fig. 24, p. 41). The body was put inside a wooden coffin which was placed on a platform at the end of the tomb chamber. A painting of the Chinese legendary figures, Fuxi and Nuwa, was hung behind the body (Fig. 23, p. 41) and the numerous figurines of servants, guards and goods (Fig. 25, p. 42) for the deceased in his afterlife were listed on a tomb inventory.

These tombs show little of the influence of Buddhism but, elsewhere, Buddhist ideas gradually merged with traditional beliefs of the empires of the Silk Road and new schools, art, iconographies and texts emerged, as seen in *The Sutra of the Ten Kings* (Fig. 26, p. 43). In Indian tradition the dead were judged over forty-nine days at seven-day intervals, their fate decided on the basis of their acts in their life. They were then consigned to be reborn as one of the seven orders of being, ranging from bodhisattvas (those who have attained enlightenment) to hungry ghosts, or to be consigned to hell. The Chinese period of mourning was three years for parents, and so to make the Buddhist idea conform to their traditional beliefs, the Chinese dead were also judged 100 days, one year and three years after their death. Of course, no text validating this belief existed in the original Indian Buddhist canon and so Chinese Buddhists composed a new text, *The Sutra of the Ten Kings*, which depicts the judges as kings of the underworld. Although uncanonical, this text became very popular in China.

The camel is the iconic traveller of the Silk Road (Fig. 27, p. 43), but few would associate rabbits with the art and iconography of this ancient trade route. Yet the same image of three rabbits running in a circle and each sharing an ear is found in sixth-century Buddhist cave temples at Dunhuang (Fig. 28, p. 44), on a Mongol coin dating to 1281 (Fig. 29, p. 44) and in numerous medieval churches in England, from a floor tile dating to c.1300 in Chester Cathedral (Fig. 30, p. 44) to a carved wooden roof boss in Spreyton Church dated to 1451. More recently, the rabbits reappeared in Victorian puzzle books. The mystery of the rabbits' journey is yet to be solved, most especially how it changed from a symbol of Buddhism to one appropriate to a Christian context, but it exemplifies the debt we all owe to this great trade route of old.

Head of the large statue of Maitreya Buddha in cave 96 at Dunhuang. This photograph was taken in 1924 by the American scholar, Langdon Warner, following a minor earthquake which had destroyed the wooden pagoda normally obscuring it. The Buddha was originally carved at the beginning of the seventh century and was repaired by the king of Dunhuang in the 966. It still stands today.
Photograph by Langdon Warner, Historic Photographs and Special Visual Collections, Fine Arts Library, Harvard University. Photo W89250-1. Copyright President and Fellows of Harvard College

AUREL STEIN (1862–1943)

For strategic reasons, its trade and abundance of natural and manufactured products, Central Asia has always been of interest to the great empires of the world. In the period covered in The British Library's Silk Road exhibition in 2004, these included the Arabs, Turks, Tibetans and Chinese. In the nineteenth century it was the Russians and British who vied for influence among the local emirs. Today, with the Caspian pipeline promising an alternative to Middle Eastern oil, the Americans have become aware of the importance of this region in the twenty-first century.

By the late nineteenth to early twentieth century, following a thaw in relations between the Russians and British and reassertion of Chinese control following the short-lived rule

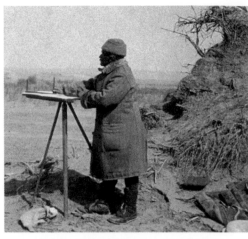

Stein at his plane table surveying the Taklamakan desert on his third expedition, 7 March 1915.
The British Library, Photo 392/28(739)

of the Turkic king of Kashgaria, Yakub Beg, the eastern Silk Road was stable enough for the explorers and archaeologists. They too were looking for treasures. For the Swedish explorer, Sven Hedin, the treasure lay in travelling previously unsurveyed and dangerous desert expanses. He noted ancient sites but did not stop to excavate with any thoroughness. For the Hungarian, Marc Aurel Stein, the goal was to discover forgotten civilisations which exemplified the cultural diversity of the Silk Road in its heyday in the first millennium.

As a young man Stein had all the skills in place to pursue a scholarly path: a PhD, language skills and knowledge of the history, geography and religion of the Indo-Iranian world and its links to the classical West. But he was not interested in scholarship from books alone: he wanted to travel to the places in the books, to see for himself how geography had moulded history – to be an explorer as well as a scholar. The barriers were considerable: he had intelligence and physical strength and determination, but he was, to put it plainly, an unknown Hungarian with no special connections or family wealth. Yet by the end of his life he had led eight major Silk Road expeditions, the longest lasting over three years and covering thousands of miles, mainly on foot, yak, camel and pony. He had explored the length of the Silk Road from Antioch on the shores of the Mediterranean to the ancient garrison town of Dunhuang in China, and surveyed many of its massive mountain ranges and vast deserts. He had discovered and excavated sites ranging from 5,000-year-old Neolithic settlements in Iran, to 2,000-year-old Chinese military fortifications and Buddhist caves dating back a millennium. From these sites he uncovered over 100,000 manuscripts, paintings, murals, statues, textiles, potsherds and items of everyday use which were given to museums worldwide. And in the midst of all this Stein held a regular job past retirement, maintained a copious correspondence with friends, colleagues and officialdom, wrote over twenty books and close on 100 articles and still managed to remember his friends' birthdays.

Stein's meticulous record-keeping has been invaluable for the study of the sites he explored and the excavated artefacts. When he arrived at a new archaeological site he surveyed the area and the site itself, drawing a clear plan to scale of the major remains. He excavated each area in

turn, making sure to record the layers at which artefacts and manuscripts were uncovered and making a note of every find, however small or fragmentary.

Stein assigned each find a unique identifier which was usually written in pen on the find itself. So, for example, the armour shown in Fig. 15 (p. 32) has the identifier 'M.I.xxiv.0040'. 'M.I.' is Stein's shortened form for the Tibetan fort at Miran. The 'xxiv' indicates the twenty-fourth place excavated within the fort, and '0040' indicates that this was the fortieth object numbered from this room. Scholars are thus able to identify the exact provenance of the vast majority of Stein's finds and to refer back to his expedition reports to read of the circumstances of the find. This helps enormously in dating and understanding the artefacts and their context.

Stein's list of provisions required for his second expedition, including ten small pots of Marmite and drinking chocolate.
The Bodleian Library, MSS Stein 296/96

Although archaeology and scholarship were the main aims of Stein's expeditions, exploration and surveying were also vital and important activities. Stein was always extremely careful to plan well so as to avoid putting his men or animals in danger. On his second expedition, in order to allow him additional excavation time at sites near Khotan, Stein decided to cross the Taklamakan desert from north to south rather than make the safer – but far longer – route around the desert. The crossing was not without hazards and relied on Stein being able to navigate successfully to the point where the Keriya river, flowing northwards from the Kunlun, disappeared into the sands of the Taklamakan. He used Hedin's maps but these had been surveyed over a decade previously and rivers running through the Taklamakan sands often change their course. Thanks largely to excellent planning and a cool head the crossing was successful, but in his letter to his great friend and regular correspondent, Percy Allen, Stein confided: 'It has been a hard march, this tramp of close on 200 miles over absolutely lifeless desert.' The letter, however, still underplays the hardships of this march and Stein's role in preventing a mutiny, which would have resulted in the almost certain death of men and animals. Desert travel was no less hazardous for Stein than for his predecessors in the first millennium, who tramped the Silk Road and left behind small traces of their lives in the artefacts shown here.

A pile of manuscripts from Dunhuang. Chinese scrolls were traditionally stored in bundles, like these shown here, inside sutra wrappers.
The British Library,
Photo
392/27(587)

SOGDIANA AND SAMARKAND: TRADE AND DIPLOMACY

Afrasiab, a grassy plateau lying north of the modern town of Samarkand (on the Zerafshan river in present-day Uzbekistan), was the site of the first city of Samarkand, from its foundation in the seventh or sixth century BC until the Mongol invasion in the thirteenth century AD. The area of Afrasiab lies in the old country of Soghd, and has had a tumultuous history because of its strategic importance to Central Asian powers. After Persian domination in the sixth to fourth centuries BC, Soghd, or Sogdiana, was subject to successive waves of invasions by the Greeks and a variety of nomadic peoples, with the Turks taking control in the mid-sixth century.

Under Turkic sovereignty, this region achieved a measure of independence as a linked series of city-states. Sogdians became the principal merchants of the Silk Road and moved to important market towns along the route, establishing sizeable communities in the Chinese capital, Chang'an, two thousand miles to the east, with more occasional but direct links to Constantinople, at about the same distance to the west.

The Sogdians had their own spoken language and from about the first century BC they adapted the Aramaic script to transcribe it. Later they used a special script to transcibe Manichaean religious documents, many having converted from Zoroastrian to this new faith from the west, and yet another script for another new faith, Buddhism, from the south. By the eighth century Sogdiana had been conquered by the Arab caliphate and gradually the population converted to Islam. The numerous influences on this strategic area left their evidence in the art and manuscripts found during excavations, both in Sogdiana and from the many Silk Road Sogdian communities.

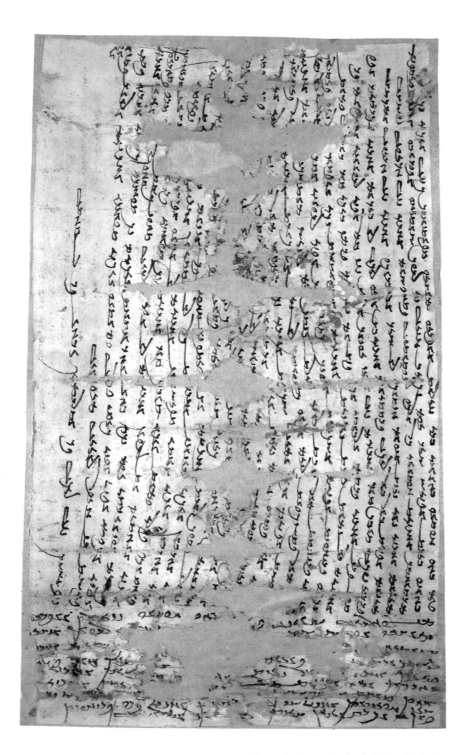

Fig. 1: A letter written in about 314 by a Sogdian merchant's wife who had been abandonded by her husband in Dunhuang. In it she complains of his treatment of her. Found by Stein in 1907 in the ruins of a watch-tower to the north-west of Dunhuang, it forms part of the contents of a postbag lost in transit. These 'Ancient Letters' are so called because they are the earliest surviving texts written in Sogdian.

c.313–14

Ink on paper; H: 26.5 cms W: 42.8 cms

Cat. 191: The British Library, Or.8212/98 (T.XII.a.ii.3)

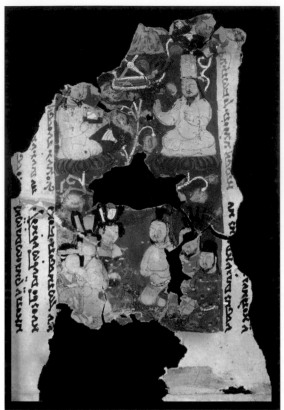

Fig. 2: Disciples of all Near-Eastern religions came to Sogdiana, either fleeing persecution or hoping to find converts. Zoroastrianism became the main religion of Samarkand but, by the fourth century, was challenged by Manichaeism. Sogdian Manichaean priests converted their neighbours, the Turkic Uighurs, and by the ninth century there was a thriving Manichaean Uighur community in Kocho, on the Silk Road near present-day Turfan. This finely illustrated copy is a Manichaean text, 'The Parable of Bashandad'. The image, oriented sideways to the text, is a sermon scene showing Manichaean priests in their white clothes and tall hats.
889-1015 (carbon dated)
Ink, pigments and gold on paper;
H: 18.8 cm W: 29.2 cm
Cat. 5: Museum für Indische Kunst, Berlin: MIK III 8259

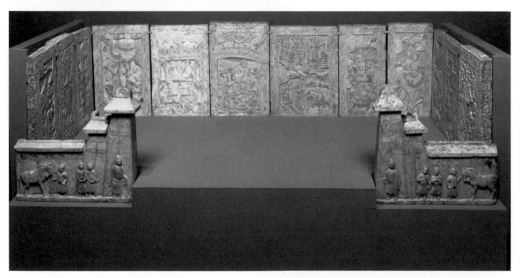

Fig. 3: Sogdian merchants formed communities all the way to north China, where they settled and married local women, growing rich on trade with their homeland. Elaborately decorated funerary couches were prepared on their deaths, such as the one shown here. The scenes depict Zoroastrian funerary rights as well as the juxtaposition of Chinese and Sogdian elements in the merchant's life. He is shown in panel e (see right) with his Chinese wife watching a Sogdian dance.
6th century
White marble with pigments and gold;
2 gateposts and 11 panels
H: 51.5-62.3 cm W: 25.4-56 cm
Cat. 1: Miho Museum, SF04.040 and SF04.014

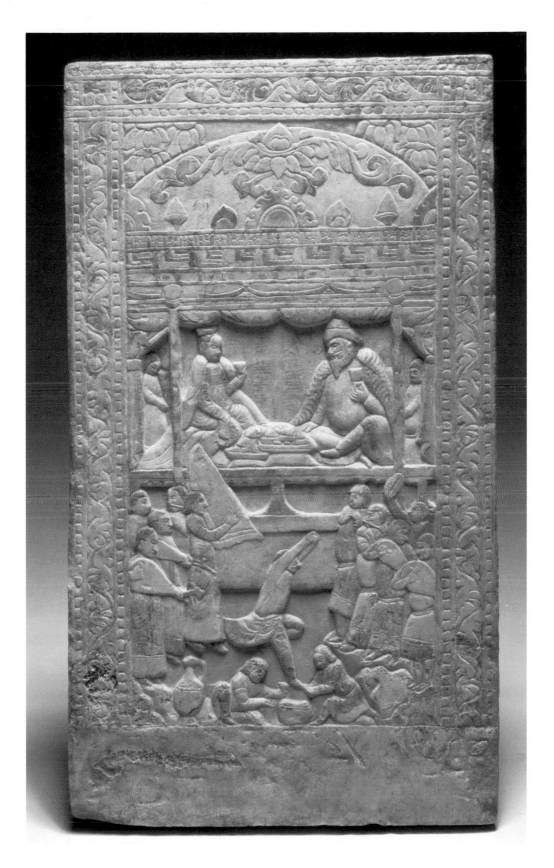

KHOTAN: A MEETING OF CULTURES

Yotkan, the site of the ancient capital of the Khotanese kingdom, lies some 10 kilometres west of the present-day town of Khotan in Xinjiang Uighur Autonomous Region, China. A semi-autonomous city-state from at least the beginning of the first millennium, the founding legends of Khotan are all associated with Buddhism, and the city's links with India and its thriving Buddhist society are attested by Chinese travellers who visited Khotan en route to India looking for Buddhist texts. However, the people and their language were Iranian.

A Chinese garrison was established at Khotan around 73 BC to secure the Silk Road. Later, the Hephthalites in the fifth century and the Tibetans, during their First Empire in the eighth and ninth centuries, interrupted Chinese control. Chinese records show that by 1006 Khotan had been conquered by the Turkic Karakhanids and Buddhism in the region replaced by Islam (although Marco Polo recorded a community of Nestorian Christians here in the late thirteenth century).

Khotan had a thriving paper industry by the fifth to sixth centuries, and also produced fine silk, wool and rugs. However, it was most famous for jade, brought down from the mountains as river boulders, which was in constant demand by the Chinese for its hardness, beauty and durability. It was probably jade that first made the Khotan kingdom an important trading stop on the southern Silk Road. Trade exposed Khotan to diverse influences and the art, manuscripts, terracottas, artefacts and coins found at its various sites (most now buried in the desert sands), including the Buddhist shrines at Dandan-Uiliq (about 130 kilometres north-east of Yotkan), reveal a rich mix of cultures.

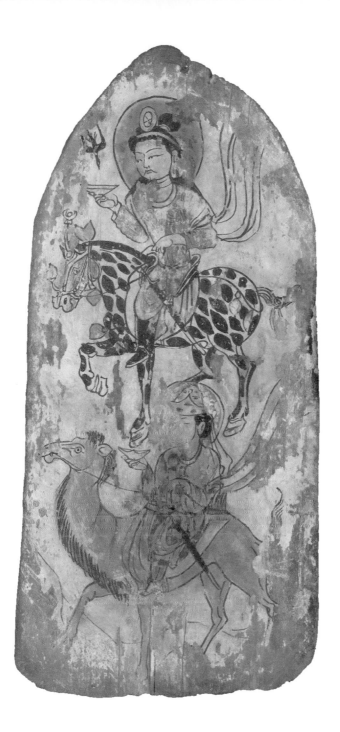

Fig. 4: Painted wooden plaques were prepared as votive offerings for the Buddhist believers of Dandan-Uiliq, a settlement in the ancient Silk Road kingdom of Khotan. The figures are drawn in Persian style, but the meaning of the black bird flying into the cup is not yet understood. The dappled horse, ancestor to the Appaloosa breed, came from the Heavenly Mountains north of Khotan, while the two-humped camel was the consummate traveller of the eastern Silk Road.

*c.*6th century
Ink and pigments on wood; H: 38.5 cm W: 18.0 cm
Cat. 59: The British Museum, 1907, 11-11.70 (D.VII.5)

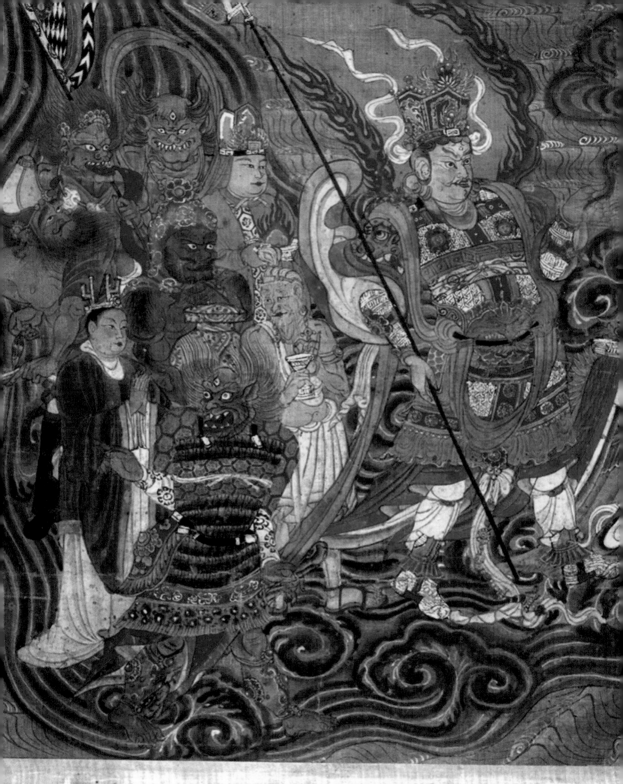

Fig. 5: Vaiśravaṇa, one of the four guardian kings of Buddhism, was particularly associated with the founding of Khotan and was often called upon to protect the state from invading armies and other threats. He is shown here in his customary armour, riding on a purple cloud across a lake in his legendary domain north of Mount Sumeru. He is identifiable by the lance and stupa.
9th century
Ink and pigments on silk; H: 37.6 cm W: 26.6 cm
Cat. 94: The British Museum, OA 1919,0101,0.45 (Ch.0018)

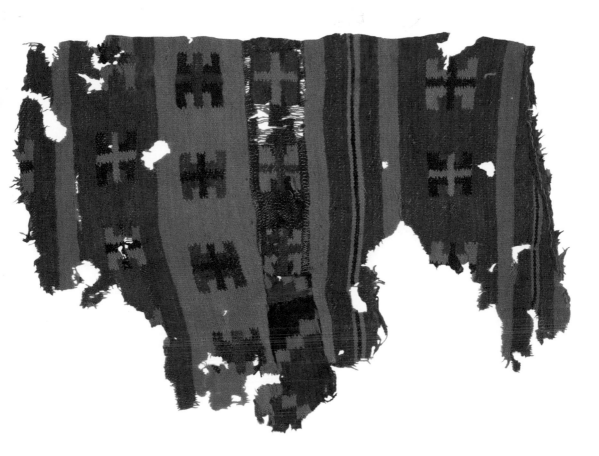

Fig. 6: Khotan was a major supplier of rugs, carpets, silks and other textiles to the eastern Silk Road. This fragmentary woven rug was found in front of a fireplace in a house dating to the third or fourth century AD in Niya, an oasis town in the kingdom of Kroraina which was Khotan's eastern neighbour. Khotanese rugs were also used as currency, mentioned in contemporary documents as being exchanged for a wife, vineyard and camels.
3rd to 4th century
Wool; L: 48 cm W: 34.5 cm
Cat. 43: The British Museum,
OA 1907,11-11.105 (N.vii.3)

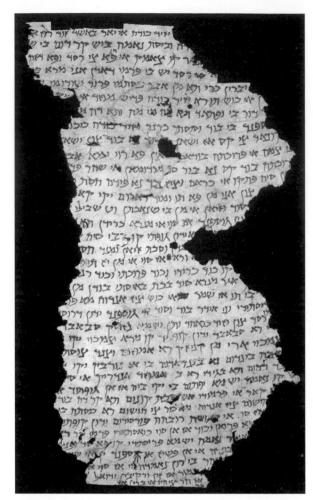

Fig. 7: Judaism was one of several religions from the ancient Near East which travelled thousands of miles along the Silk Road, through Samarkand and into China. However, little evidence remains of Silk Road Jewish communities. This eighth-century letter is unique among eastern Silk Road finds. It is the earliest example of a document of any length in New Persian and is written in Hebrew script. It concerns the trade of sheep and sale of garments.

8th century
Ink on paper; H: 45.5 cm W: 38 cm
Cat. 147: The British Library, Or.8212/166
(D.XIII)

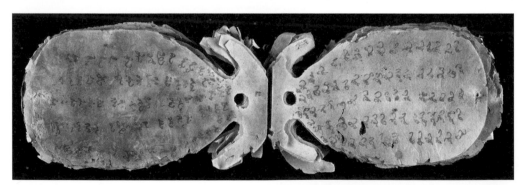

Fig. 8: When documents first began to be discovered among the desert ruins of the eastern Silk Road some appeared in unknown languages and in strange formats, such as the little fish-shaped booklet shown here, bound with a copper peg. The script resembled the Indian Brāhmī script but, on close examination, it was realised that it was a forgery. Hundreds of similar forgeries were made by a Khotanese man, Islam Akhun, and his colleagues, and sold to the British and Russian consuls.

c.1896
Ink on paper; H: 8 cm W: 12.5 cm
Cat. 142: The British Library, Or.13873/58
(Hoernle Collection M2)

KRORAINA AND NIYA: EVERYDAY OASIS LIFE

Stretching east from Khotan was a string of oases which formed the settlements of the southern Silk Road. These pockets of settled life with caravanserais (inns with courtyards for travelling merchants and their camels), formed near small rivers or in the inland deltas where the rivers disappeared into the sands of the Taklamakan desert. Fortified oasis-states were established in these areas as early as the middle of the first millennium BC and they flourished with the Silk Road. But by the time the great Buddhist pilgrim Xuanzang left an account of his journey there in the seventh century, the southern route had declined and many oasis settlements had reverted to desert. In the extreme aridity of the Taklamakan desert climate, whole landscapes of abandoned towns and farmsteads with their vineyards and orchards still standing, were swallowed up by drifting sand dunes. One of the best preserved of these is Niya, once an important town on the western edge of the thriving Silk Road kingdom of Kroraina.

Among the remains discovered here by Stein were hundreds of wooden tablets and leather documents written in the Gāndhārī language in a script unique to Central Asia. The names and vocabulary found in these gives us an idea of the diversity of the peoples encountered in the kingdom of Kroraina. While telling us little about the history of armies and empires, these everyday letters, administrative and legal records, tax returns and similar documents, open an intimate window onto the realities of daily life along the southern Silk Road in the third to fourth century AD.

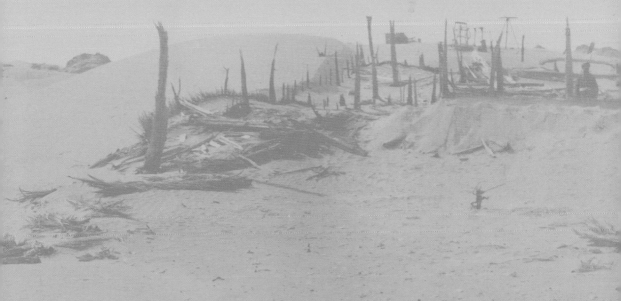

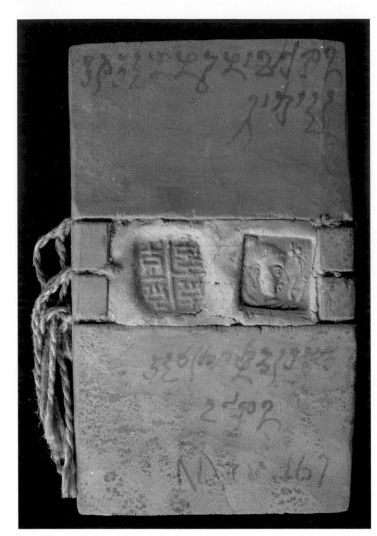

Fig. 9: In the third- and fourth-century desert kingdom of Kroraina, wood was used as the primary writing material for the many administrative documents. The language was a Middle Indian language, known as Gāndhārī because it originated in the Gandhāran region around present-day Taxila. It was written from right to left (unlike other Indian languages) using Kharoṣṭhī, a script unique to the Silk Road. Two pieces of specially cut wood, with the message on the inside, were secured with string and clay seals showing a Greek deity and Chinese characters.
3rd to 4th century
Ink on wood with clay and string; H: 7.7 cm W: 13.2 cm
Cat. 47: The British Library, Or.8211/1617 (N.xv.167)

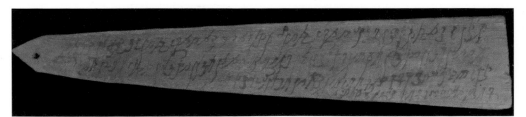

Fig. 10: Women along the Silk Road enjoyed various rights and often held powerful roles in society. There is evidence of one ancient matriarchal society and in other Silk Road kingdoms, such as Kroraina, women could inherit property and had certain legal rights. The wooden document shown here is from the king to the local governor concerning a dispute over local bride-price, although it emphasizes the free will of women within the official marriage law.
3rd to 4th century
Ink on wood; H: 4.9 cm W: 25.4 cm
Cat. 89: The British Library, Or.8211/1444 (N.xxiv.viii.54)

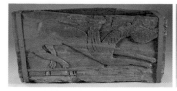 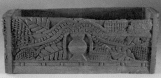

Fig. 11: Stein discovered this carved beam in a ruined house where it had fallen in the ancient settlement of Niya, in the Taklamakan desert, almost two thousand years after the town was deserted. Part of the public apartments of a large house, in a room with a raised sitting platform on three sides around an open fireplace, the beam is decorated with a well-designed motif of a vase holding long-stemmed plants, flanked by monsters with crocodile heads, winged bodies and lions' feet.
3rd to 4th century
Wood; L: 252 cm W: 36.8 cm D: 26.7 cm
Cat. 72: The National Museum, New Delhi, 2003/6/1537 (N.xxvi.iii.1)

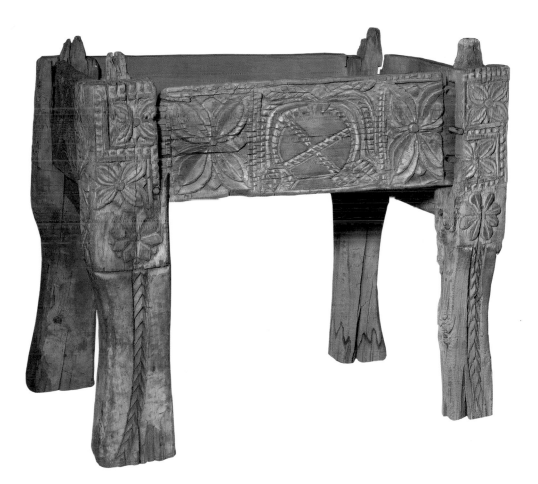

Fig. 12: The ancient settlements of Kroraina are identifiable by the wood skeletons of the houses preserved in the desert sands. Local poplar wood was used both for building and furnishings, such as the carved frame shown here. This was a stand for a table or a Buddhist altar. The carvings show eight-petalled lotus, four-petalled clematis and, in the centre, a garlanded stupa or Buddhist shrine.
3rd to 4th century
Wood; H: 60 cm L: 67.8 cm D: 45 cm
Cat. 73: The British Museum, OA 1907,11-11.85 (N.vii.4)

MIRAN:
WARRING EMPIRES

Miran is situated to the east of Niya where the barren Lop desert meets the forbidding Altun Shan mountains. Over two thousand years ago, a river flowing from the mountains irrigated the land around Miran, one of the smaller settlements in the kingdom of Kroraina. As the Kroraina kingdom flourished, Miran developed as an early centre of Buddhism. Many monasteries, shrines and temples were built in the area, decorated with painted friezes and sculptures. The influences of Gandhāra, in present-day Pakistan, and regions even further west can be seen in these artistic works.

After the fourth century, the kingdom of Kroraina declined and the branch of the southern Silk Road through the Lop desert became much more difficult to travel. It was not until the conquering Tibetan armies arrived in the eighth century that Miran was occupied again. Miran lay at the end of one of the mountain passes over which the Tibetan armies crossed into Central Asia, and was an ideal location for them to establish a defensive garrison, building a fort and establishing a community using the town's old irrigation system. They remained in Miran from the eighth century until after the Tibetan Empire crumbled in the mid-ninth century.

The great majority of manuscripts found in the Miran region are Tibetan documents from the fort. These are mainly written on wood, and largely comprise official documents, contracts and military communications. They are some of the earliest examples of Tibetan writing. The ancient fort also yielded many examples of broken and discarded everyday objects such as scales of armour, balls of wool, leather pouches and mousetraps.

Fig. 13: In the early seventh century the many small kingdoms of the Tibetan plateau south of the Silk Road were unified to form the First Tibetan Empire. This powerful alliance vied with the Chinese, Arabs and Turks for control of the Silk Road over the next two centuries. This is one of two documents from the Library Cave at Dunhuang, which record the annals of the Tibetan emperors from 629 to 764. The other side of the scroll contains a Buddhist sutra in Chinese. Paper was often reused after the Tibetans took control of Dunhuang in 781.
9th century
Ink on paper; H: 25.8 cm W: 364 cm
Cat. 93: The British Library, IOL Tib J 750

Fig. 14: Paper was invented in China in about the first century BC, but wood continued to be used for everyday ephemeral documents along the Silk Road. The document shown here is inscribed with the name of an outlying hill-station where a group of four soldiers from the Tibetan army on the Silk Road were stationed on watch duty. The soldiers were given the small wedge of wood cut away from this main piece after notches had been scored across. The couriers bringing provisions carried the master slip, and the two pieces were then fitted together to make sure the notches matched up when the provisions were delivered. A record of delivery was inscribed on the back.
8th to 9th century
Ink on wood; H: 1.8 cm W: 12 cm D: 0.4 cm
Cat. 102: The British Library, IOL Tib N 1541 (M.Tagh.a.II.0065)

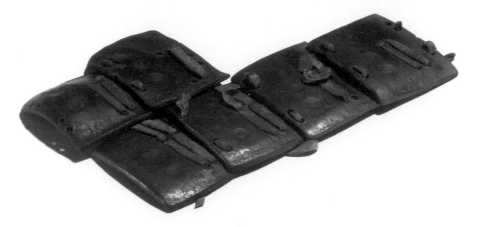

Fig. 15: Images of soldiers along the length of the Silk Road show that they wore suits of armour made from scales of both metal and leather. The leather scales shown here were discovered in the eighth- to ninth-century Tibetan fort at Miran, and were lacquered for decoration and to increase their toughness.
8th to 9th century
Leather with lacquer; H: 15.5 cm W: 21.2 cm
Cat. 109: The British Museum, OA MAS 621 (M.I.xxiv.0040)

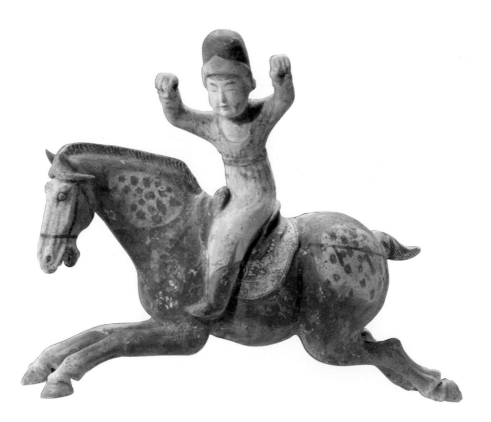

Fig. 17: Polo, developed among the horse-riding nomads of Central Asia, became popular among the eighth-century Chinese aristocracy. Stirrups, invented a few centuries earlier, and the high-fronted saddle, helped with stability when wielding a polo stick. Men and women both adopted the 'foreigner's dress' of a short robe with trousers tucked into leather boots for convenience.
8th century
Terracotta with traces of slip and pigments; H: 30 cm
Cat. 176: Private Collection

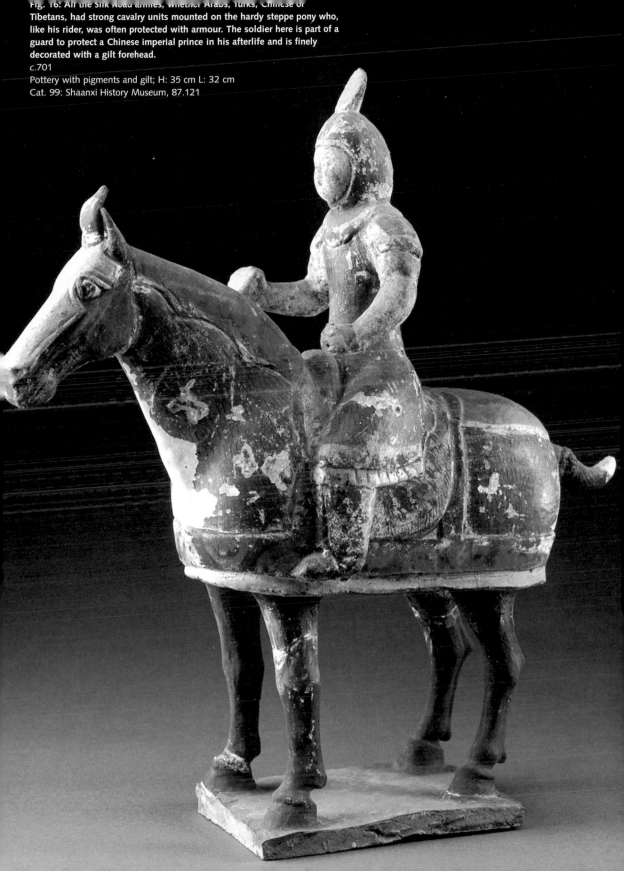

Fig. 16: All the Silk Road armies, whether Arabs, Turks, Chinese or Tibetans, had strong cavalry units mounted on the hardy steppe pony who, like his rider, was often protected with armour. The soldier here is part of a guard to protect a Chinese imperial prince in his afterlife and is finely decorated with a gilt forehead.

*c.*701

Pottery with pigments and gilt; H: 35 cm L: 32 cm

Cat. 99: Shaanxi History Museum, 87.121

DUNHUANG: OFFICIAL LIFE AND FAITH

Dunhuang, a small town in present-day Gansu province, western China, has a history of over 2,000 years. The original town (west of the present-day city which was only built in 1725) was established as a military garrison by the Chinese after its soldiers had defeated the nomadic Xiongnu who had previously occupied this area. The Chinese used the garrison as a staging post for their campaign in 104 BC to conquer lands further west. By 100 BC they had reached as far as the Ferghanan valley between Kashgar and Samarkand.

Dunhuang, on the junction where the main Silk Road trade route split into northern and southern branches around the Taklamakan desert, grew and prospered. The pilgrim monk Faxian described it as the chief town on the frontier region when he passed through on his way to India in 400 AD. By this time, Yuezun, an itinerant monk, had excavated a meditation cave in a cliff face just outside the town after having had a vision of golden radiance in the form of a thousand Buddhas. Others followed and by the early fifth century the first cave temples were excavated, painted statues of Buddha and his attendants placed inside, and their walls and ceilings painted with thousands of Buddha images.

In the ninth and tenth centuries, Dunhuang became a semi-autonomous kingdom. The town later fell under the control of both the Tangut and then the Mongol empires, but activity on the caves continued, with each ruling power painting the caves according to their own style and beliefs. But with soldiers and settlers, merchants, monks and others passing along the Silk Road through the millennia, the languages of Dunhuang's manuscripts and inscriptions, and the artistic styles of its cave and silk paintings, reflect the diversity of its visitors. The last confirmed artistic activity at the cave site was in 1357.

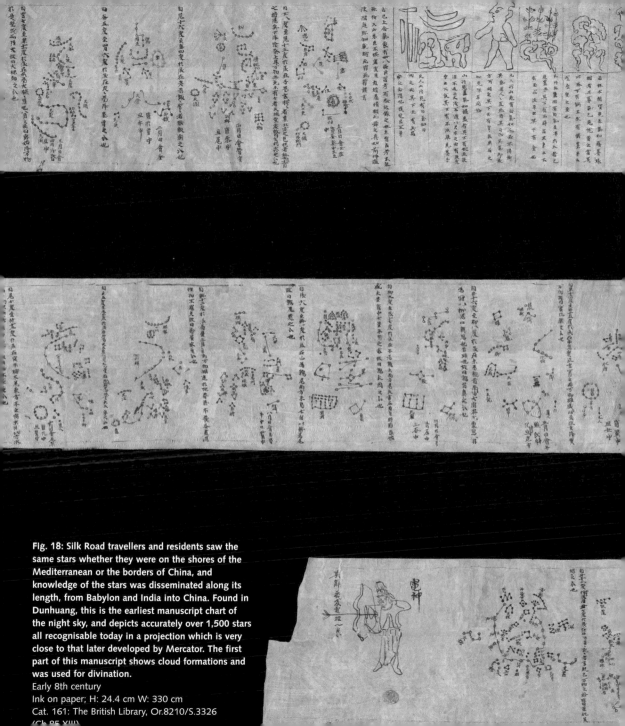

Fig. 18: Silk Road travellers and residents saw the
same stars whether they were on the shores of the
Mediterranean or the borders of China, and
knowledge of the stars was disseminated along its
length, from Babylon and India into China. Found in
Dunhuang, this is the earliest manuscript chart of
the night sky, and depicts accurately over 1,500 stars
all recognisable today in a projection which is very
close to that later developed by Mercator. The first
part of this manuscript shows cloud formations and
was used for divination.

Early 8th century
Ink on paper; H: 24.4 cm W: 330 cm
Cat. 161: The British Library, Or.8210/S.3326
(Ch.85.XIII)

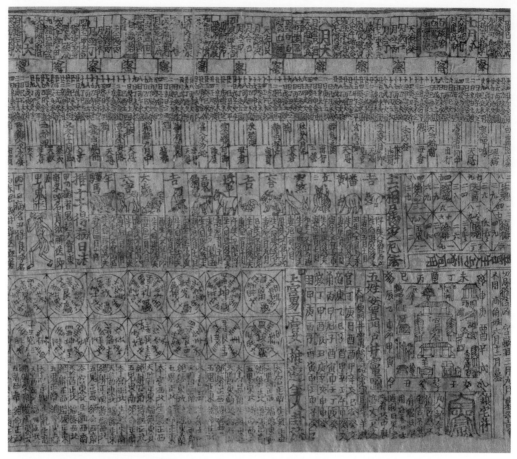

Fig. 19: Unlike the Buddhists, private printers were interested in developing the new technology of printing for monetary rather than religious gain. One of the most popular types of book in China in this period – and up to the present – was the almanac. Although only the emperor's astronomers were entitled by law to calculate the calendar, in reality private almanacs abounded. This is the most complete printed almanac found at Dunhuang and dates from 877. It shows the animals of the Chinese zodiac (see detail below), *fengshui* diagrams and lucky days.

877
Ink on paper: woodblock print; H: 29 cm W: 115.5 cm
Cat. 264: The British Library: Or.8210/P.6 (Ch.91.I.3)

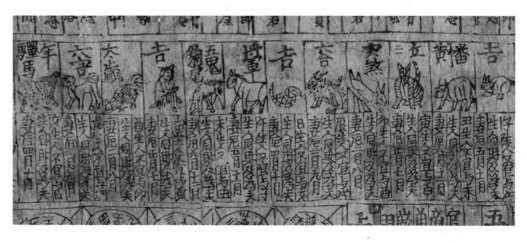

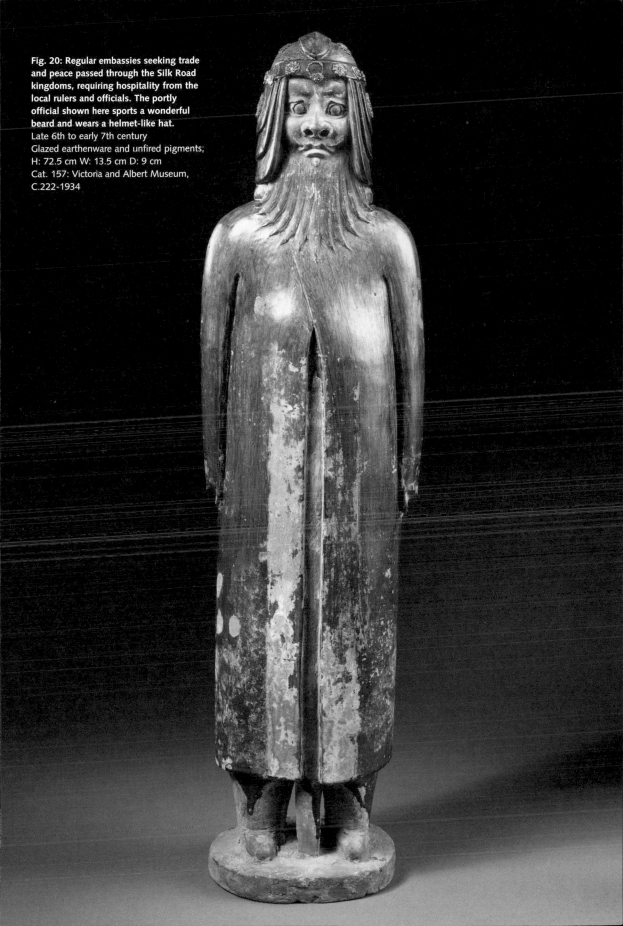

Fig. 20: Regular embassies seeking trade and peace passed through the Silk Road kingdoms, requiring hospitality from the local rulers and officials. The portly official shown here sports a wonderful beard and wears a helmet-like hat.
Late 6th to early 7th century
Glazed earthenware and unfired pigments; H: 72.5 cm W: 13.5 cm D: 9 cm
Cat. 157: Victoria and Albert Museum, C.222-1934

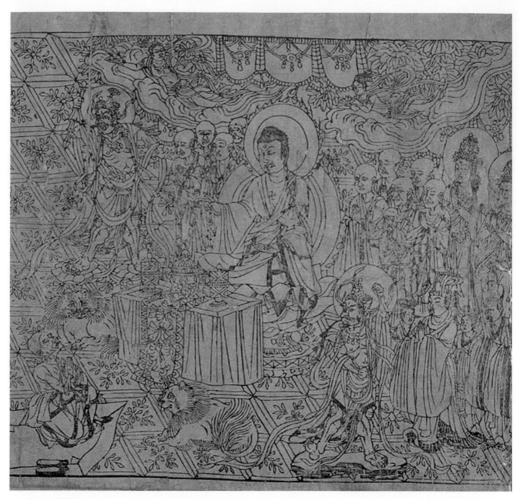

Fig. 21: Buddhist sutras encourage their own duplication, whether by reciting or writing, in order to disseminate the word of the Buddha and increase merit in the world. Printing made possible the mass duplication of sutras and was soon used by pious individuals, such as Wang Jie, who paid for the printing of the Diamond Sutra for the merit of his mother and father. This copy, with its elaborate frontispiece showing Buddha in discussion with his elderly disciple Subhuti, is dated to 868 making it the earliest, dated printed book in the world. It is, however, the product of a mature printing industry.

868
Ink on paper: woodblock print; H: 27 cm W: 499.5 cm
Cat. 262: The British Library: Or.8210/P.2 (Ch.ciii.0014)

ASTANA:
DEATH AND THE AFTERLIFE

The Tianshan or Heavenly Mountains rise from north-east of Samarkand and extend eastwards to the western borders of China. Their snowy peaks form a backdrop to travellers on the northern branches of the eastern Silk Road, which follow the mountains to their north and south. At the eastern end, the mountains branch to skirt the Tarim Basin, which at 154 metres below sea level is the second lowest depression on earth (after the Dead Sea), and the two northern routes join again for the final leg east to China. Further routes lead north to the fertile grazing of the Dzungarian Basin and from there into the grasslands of what is now Mongolia. To the south, the route crosses the Gobi to join with the southern route near Dunhuang. The area's strategic importance was quickly understood by all the eastern Silk Road powers and the Chinese established a garrison at the northern edge of the Tarim Basin, where meltwater, fertile soil and searing heat produce fine crops, especially grapes.

From the fifth century the capital was at Gaochang, a large walled city on the plain south of the mountains. The area fell under the control of several nomadic powers before being taken by the Chinese in 640. Two centuries later it was taken by the Uighurs, a powerful confederation of Turkic tribes who called the capital Kocho. Over the following centuries, like all the ancient Silk Road kingdoms, the area fell under the control of various regimes, including the Mongols from the north-east in the thirteenth century. In the late fourteenth century the city was moved to the present-day site of Turfan.

The Chinese used the large plain north of Gaochang as a cemetery from the late fourth century onwards. The area – now known as the Astana and Karakhoja cemetery – covers ten square kilometres and contains hundreds of tombs. Epitaph tablets recorded details of the deceased and clay monsters guarded the tomb entrances. Tomb inventories listed the models of servants, guards, utensils and animals placed in the tomb for the afterlife. Almost all the manuscripts from the tombs are in Chinese, but Manichaean texts in Sogdian and Uighur and numerous Buddhist texts in various languages have been found in the ancient city itself.

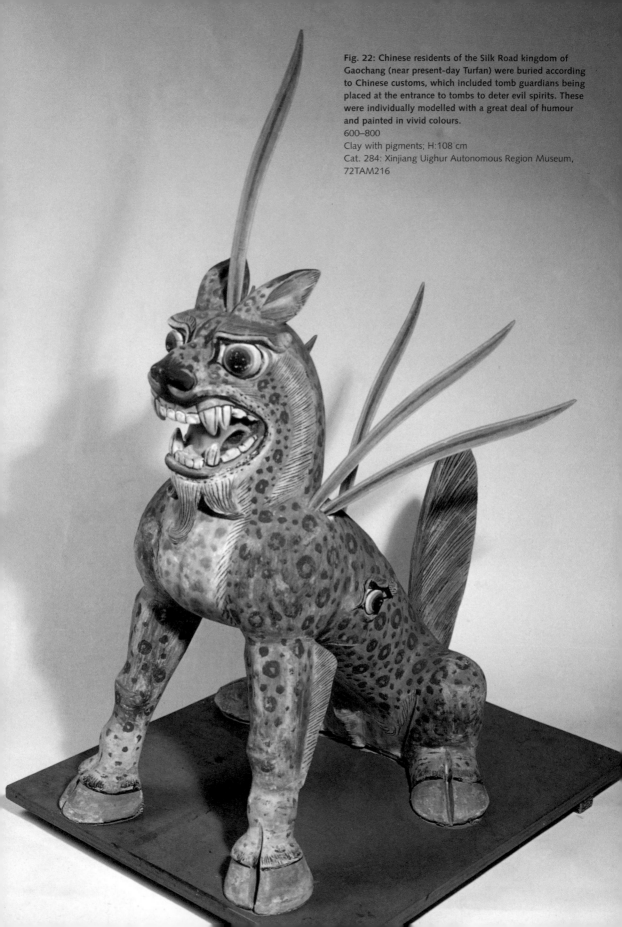

Fig. 22: Chinese residents of the Silk Road kingdom of Gaochang (near present-day Turfan) were buried according to Chinese customs, which included tomb guardians being placed at the entrance to tombs to deter evil spirits. These were individually modelled with a great deal of humour and painted in vivid colours.
600–800
Clay with pigments; H:108 cm
Cat. 284: Xinjiang Uighur Autonomous Region Museum, 72TAM216

Fig. 23: Fuxi and Nuwa are mythical forebears of the Chinese mythology, credited with diverting floods, divination, domestication of animals, the invention of silk and other skills of the ancient Chinese. Many of the Chinese tombs at Gaochang contained paintings like this, on silk and hemp, showing the couple against a background of the sun, moon and stars, and holding a pair of compasses and a set square. These refer to the creation of the round earth and the square heavens.
600-800
Pigments on silk; H: 235 cm W: 106 cm
Cat. 294: National Museum, New Delhi 2003/17/347
(Ast.ix.2.054)

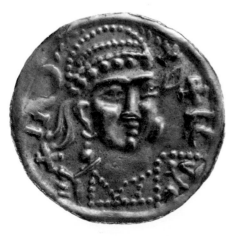

Fig. 24: Although the burials at the Silk Road kingdom of Gaochang followed Chinese traditions, scholars are in dispute about the origins of placing coins inside the mouth of the corpse. Some see links with an ancient Greek custom of leaving a coin for the deceased to tip the ferryman of Hades. The coins found in Gaochang included those minted in China, others minted locally but in Chinese style, some imitating Byzantium coins – such as the one shown here – and genuine gold and silver drachmas. They reflect the wide diversity of currencies in use on the Silk Road.
5th to 6th century
Gold; Diameter: 1.6 cm Weight: 0.85 g
Cat. 37a: The British Museum, Stein (IA.XII.c.1)

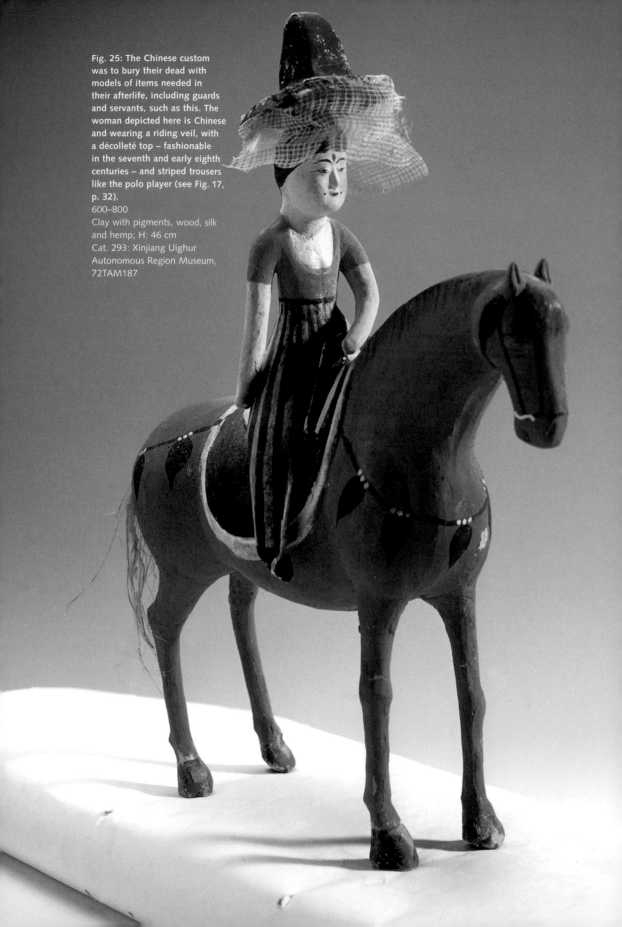

Fig. 25: The Chinese custom was to bury their dead with models of items needed in their afterlife, including guards and servants, such as this. The woman depicted here is Chinese and wearing a riding veil, with a décolleté top – fashionable in the seventh and early eighth centuries – and striped trousers like the polo player (see Fig. 17, p. 32).
600–800
Clay with pigments, wood, silk and hemp; H: 46 cm
Cat. 293: Xinjiang Uighur Autonomous Region Museum, 72TAM187

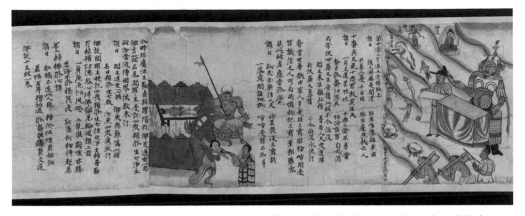

Fig. 26: As Indian ideas merged with Chinese ones along the Silk Road, the belief that the dead were brought before ten judges was legitimized in an apocryphal 'sutra' – *The Sutra of the Ten Kings*. The tenth king decides whether the deceased is reborn into a higher or lower path: as a god or human, animal, hungry ghost or into hell. This is followed by an image of hell and its tortures.
10th century
Ink and pigments on paper; H: 29 cm W: 491 cm
Cat. 297: The British Library. Or.8210/S.3961

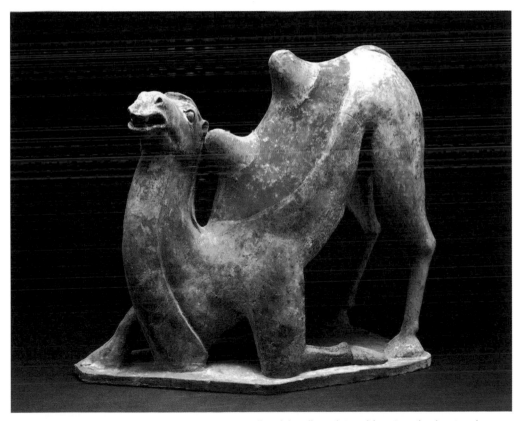

Fig. 27: The two-humped camel was the consummate traveller of the Silk Road. Found from Samarkand eastwards (his single-humped cousin dominated the lands to the west), he was able to carry large loads and survive for up to a fortnight without water. In the winter he grew a thick coat to survive the bitter desert nights of the Taklamakan and Gobi, and he was able to predict the dangerous desert winds.
7th century
Terracotta; H: 37 cm L: 34 cm
Cat. 267: Musée Guimet, Paris MA 6842

Figs. 28-30: The three images here depict the same motif – three rabbits or hares each sharing an ear and chasing each other in a circle – yet they are found in different Silk Road contexts. The top image is from the ceiling of a late sixth/early seventh-century Buddhist cave at Dunhuang. The middle image shows a Mongol coin dating to 1281–82 and from an Islamic context. The bottom image is a floor tile from Chester Cathedral in England and dates to about 1300. The travels of these three rabbits from the early Buddhist Silk Road, along the Islamic Silk Road lands and into medieval Christian Europe, has yet to be fully understood but they exemplify the iconographical complexities of the arts of these ancient trade routes.

Fig 28: Late 6th/early 7th century
Photograph courtesy of the Dunhuang Academy

Fig 29: 1281-82 (680AH)
Copper: Diameter 2.5 cm
Cat. 245: Private Collection

Fig 30: c.1300
Fired clay: H: 13.5 cm W: 13.5 cm D: 4 cm
Cat. 246: Grosvenor Museum, Chester City Council
Photograph courtesy of Chris Chapman

CONSERVATION AND DIGITIZATION

The dryness of the desert conditions ensured that the Silk Road manuscripts, paintings and artefacts such as those shown in this book were excellently preserved. However, many of them were in a very poor and fragile state when they were first discarded by the denizens of the Silk Road over a thousand years ago. Most therefore required conservation just to make them stable and thus suitable for handling by scholars and for display. But both handling and displaying compromise the life of objects. The conundrum for all institutions holding delicate material of immense scholarly importance, is how to make it more accessible for this generation of scholars while ensuring its preservation for future generations. The question of accessibility is also complicated by the dispersal of Silk Road material into different collections worldwide.

In 1993 conservators, curators and scientists from all the major collections of Dunhuang material met to address these issues and they agreed on a long-term collaboration to ensure the preservation of and increased access to this material. The International Dunhuang Project (IDP) was therefore established in early 1994 with its secretariat at The British Library to co-ordinate this collaboration.

Apart from co-ordinating two-yearly conservation conferences for members to discuss their latest work and learn about new techniques and scientific methods, one of IDP's first activities was to design a database to ensure that the material was catalogued according to international standards. By 2003 the database contained records for 50,000 Silk Road manuscripts, textiles, paintings, artefacts and historical photographs. The conservation history is almost completed on these records, along with data from all previously published catalogues. Indexes and concordances of the various catalogue numbers and the institutional pressmarks ensure that users can readily call up information on any item.

Conservation of a Chinese scroll from Dunhuang (Or.8210/S.4193). The British Library Oriental Conservation Studio now uses Japanese hand-made paper to reinforce fragmentary manuscripts. This makes them stable for long-term preservation and handling by readers.

Paper for edge repair after it has been cut to match the damaged edge of the original manuscript.

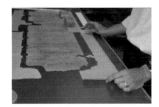

Repair pieces being prepared for attachment.

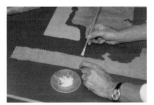

Starch paste being applied to repair edge.

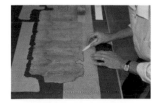

Repair paper being attached to the edge using a bone.

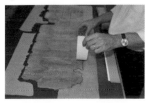

Blotting paper is used to dry the repair.

After repair paper has been attached, the scroll is then left on a drying board for three months.

To address the issue of access, IDP has been taking high-quality digital photographs of the items since 1997 and these have been freely accessible on the web database since 1998 (http://idp.bl.uk) with a Chinese web site hosted by the National Library of China online since 2003 (http://idp.nlc.gov.cn).

IDP aims to contextualise the finds and present further resources alongside the catalogue records. Bibliographical information on relevant articles, papers and books is entered and linked to the image and cataloguing record. Information about the sites where the objects were found is also given, with site plans, descriptions from the archaeological reports and both historical and contemporary photographs. Education resources are also available on IDP's special topics pages and, using the personalized web space, users can customize these for their own use and store their own research.

Although some scholars will still need to consult the original artefacts, the IDP database enables many more scholars to access this wonderful resource and to view objects from disparate collections in one place. Thus access to the material is increased and yet the objects are preserved for future generations.

BIBLIOGRAPHY

GENERAL: ART, HISTORY AND RELIGION
Baumer, Christoph. *The Southern Silk Road*.
Bangkok: White Orchid Books 2000.

Foltz, Richard. *Religions of the Silk Road*.
Basingstoke: MacMillan 1999.

Schafer, Edward H. *The Golden Peaches of
Samarkand: A Study of Tang Exotics*. Berkeley,
Los Angeles: University of California Press 1963.

Snellgrove, David and Richardson, Hugh. *A
Cultural History of Tibet*. Boulder: Prajna Press
1980.

Tucker, Jonathan. *The Silk Road, Art and
History*. London: Philip Wilson 2003.

Watt, J. and Wardwell, A. *When Silk
was Gold: Central Asian and Chinese Textiles*.
London: Metropolitan Museum1997.

Whitfield, Susan, *Life Along the Silk Road*.
London: John Murray 1999

Whitfield, Susan *The Silk Road: Trade, Travel,
War and Faith*. (Catalogue of the exhibition held
at the British Library, 7 May to 12 September,
2004). London: The British Library 2004.

Whitfield, Roderick and Anne Farrer *Caves of a
Thousand Buddhas*. London: The British
Museum 1990.

Whitfield, Roderick, Whitfield, Susan and
Agnew, Neville; Photographs by Lois Conner
and Wu Jian. *Cave Temples of Dunhuang: Art
and History on the Silk Road*. London: The
British Library 2000.

Wood, Frances. *The Silk Road: 2000 Years in
the Heart of Asia*. London: The British Library
2003.

STEIN AND OTHER EXPLORERS
Dabbs, J.A. *History of the Discovery and
Exploration of Chinese Turkestan*. The Hague:
Mouton and Co. 1963.

Hedin, Sven. *My Life as an Explorer*. London:
Kodansha 1996.

Hopkirk, Peter. *Foreign Devils on the
Silk Road*. London: John Murray 1960.

Meyer, Karl and Shareen Blair Brysac.
Tournament of Shadows. Washington:
Counterpoint 1999.

Mirsky, Jeannette. *Sir Aurel Stein:
Archaeological Explorer*. Chicago: University
of Chicago Press 1977.

Stein, M. Aurel.
 Sand Buried Ruins of Ancient Khotan.
 London: Fisher and Unwin 1903 (facsimile
 reprint of 2nd ed. (London: Hurst and
 Blackett 1904) New Delhi: Asian Educational
 Services 2000).

 Ancient Khotan. Clarendon Press: Oxford
 1907 (facsimile reprint New Delhi: Cosmo
 Publications 1981).

 Ruins of Desert Cathay. London: Macmillan
 and Co. 1929 (reprint New York: Dover
 Publications 1987 and New Delhi: Asian
 Educational Services 1996).

 Serindia. Oxford: Clarendon Press 1921
 (facsimile reprint New Delhi: Motilal
 Banarsidass 1980).

 Innermost Asia. Oxford: Clarendon Press
 1928 (facsimile reprint New Delhi: Cosmo
 Publications 1981).

 On Alexander's Tracks to the Indus.
 London: Macmillan and Co. 1929 (facsimile
 reprint New Delhi: Asian Educational
 Services 1996).

 On Central Asian Tracks. London:
 Macmillan and Co. 1933.

Wang, Helen. *Sir Aurel Stein in* The Times.
London: Saffron Books, 2002.

Whitfield, Susan. *Aurel Stein and the
Silk Road*. London: British Museum Press 2004.

Whitfield, Susan. *Historical Dictionary of
Exploration of the Silk Road*. Scarecrow
Press 2005 (forthcoming).

Wriggins, Sally Hovey. *Xuanzang: A Buddhist
Pilgrim on the Silk Road*. Boulder: Westview
Press 1996.

THE SILK ROAD
Trade, Travel, War and Faith

An exhibition at The British Library
7 May – 12 September 2004

In association with The British Museum
Sponsored by the Pidem Fund

Front cover illustration: A tomb guardian from a Chinese burial at Astana cemetery north of Gaochang (see p. 40). Cat. 284. Xinjiang Uighur Autonomous Region Museum 72TAM216.

Title-page illustration: Stein's guides and camel on his third Silk Road expedition on an ice-covered stream south of Turfan. The British Library, Photo 392/28(728).

First published 2004 by
The British Library
96 Euston Road
London
NW1 2DB

Text © 2004 Susan Whitfield
Illustrations © 2004 The British Library Board and other named copyright holders

British Library Cataloguing-in-Publication Data
A catalogue record for this book is available from The British Library

ISBN 0 7123 4866 2

Designed and typeset by The British Library Corporate Design Office
Map by Jerry Fowler
Printed in Great Britain at the University Press, Cambridge

'Cat.' in captions refers to the catalogue number of the item as featured in the full exhibition catalogue The Silk Road: Trade, Travel, War and Faith edited by Susan Whitfield (British Library, 2004).